MW01445572

NEW ARCHITECTURE NEW YORK

NEW ARCHITECTURE NEW YORK

PAVEL BENDOV

PRESTEL
MUNICH — LONDON — NEW YORK

- 6 INTRODUCTION ALEXANDRA LANGE
- 10 WHITNEY MUSEUM OF AMERICAN ART
- 16 THE HIGH LINE
- 22 HL23
- 26 10 HUDSON YARDS
- 30 VIA 57 WEST
- 36 THE NEW YORK TIMES BUILDING
- 40 THE MORGAN LIBRARY & MUSEUM
- 46 7 BRYANT PARK
- 48 432 PARK AVENUE
- 52 ONE57
- 56 TIME WARNER CENTER
- 62 HEARST TOWER
- 66 LINCOLN CENTER FOR THE PERFORMING ARTS
- 74 HAYDEN PLANETARIUM
- 78 170 AMSTERDAM
- 82 SUGAR HILL DEVELOPMENT
- 86 NORTHWEST CORNER BUILDING
- 90 JEROME L. GREENE SCIENCE CENTER
- 94 ROY AND DIANA VAGELOS EDUCATION CENTER
- 98 CAMPBELL SPORTS CENTER
- 102 VIA VERDE
- 104 FRANKLIN D. ROOSEVELT FOUR FREEDOMS PARK
- 110 JANE'S CAROUSEL
- 114 BARCLAYS CENTER
- 120 LEFRAK CENTER AT LAKESIDE

CONTENTS

- 124 SUNSET PARK MATERIAL RECOVERY FACILITY
- 130 NEW YORK BY GHERY
- 134 FULTON CENTER
- 140 56 LEONARD
- 144 SPRING STREET SALT SHED
- 148 165 CHARLES STREET
- 152 IAC BUILDING
- 156 100 ELEVENTH AVENUE
- 160 551 WEST 21ST STREET
- 162 ONE MADISON
- 166 THE NEW SCHOOL UNIVERSITY CENTER
- 170 41 COOPER SQUARE
- 174 51 ASTOR PLACE
- 178 10 BOND STREET
- 182 40 BOND
- 186 NEW MUSEUM
- 190 SPERONE WESTWATER GALLERY
- 192 BLUE RESIDENTIAL TOWER
- 196 ONE WORLD TRADE CENTER
- 200 7 WORLD TRADE CENTER
- 204 4 WORLD TRADE CENTER
- 208 NATIONAL SEPTEMBER 11 MEMORIAL
- 214 NATIONAL SEPTEMBER 11 MEMORIAL MUSEUM'S PAVILION
- 218 WORLD TRADE CENTER TRANSPORTATION HUB [THE OCULUS]

ALEXANDRA LANGE

INTRODUCTION

"We can stop waiting for state officials to produce plans for redeveloping the city's Financial District," wrote *New York Times* architecture critic Herbert Muschamp on December 14, 2001. "The Rebuilding of New York has already begun." The structure he heralded as New York's first new building since the destruction of the Twin Towers on September 11, 2001, could not have been more different than Minoru Yamasaki's skyline-topping, 1,300-foot-tall (396 m), aluminum-clad behemoths. It was a scant six stories, with a faceted, largely windowless bronze alloy facade designed to be seen head-on, like a geometric bas-relief. Inside, rather than one hundred stories of offices, capped with a spectacular restaurant, the town-house-size floors wound around the handmade and homemade collections of the American Folk Art Museum.

What Muschamp found at architects Tod Williams and Billie Tsien's "fireside" was "intimacy, companionship, aspiration—accessible to modern audiences." The museum's dark, rich, textured interior seemed to him a humanist critique of the technological determinism represented by the towers. Could it represent a way forward for architecture, and for New York City, temporarily discombobulated by the gaping ruins at Ground Zero?

The answer was yes, and no.

In the years since 9/11, New York has seen tremendous rebuilding. In the Financial District, two towers have been replaced by four, plus an Oculus and a memorial.

While Ground Zero lagged, developers found room for megaprojects at Hudson Yards, on Manhattan's West Side, and Atlantic Yards (home of the Barclays Center), at the crossroads of two major avenues in Brooklyn. The once-industrial East River waterfront became a still-evolving zipper of contemporary parks and glassy residential towers, their heights rivaling those of bridges that once presided over low sheds and slips. Midtown, which felt finished in the 1970s when the Twin Towers were completed downtown, sloughed off a layer of old buildings and began rising to new heights. Most spectacularly of all, in a windy corner at the end of West 57th Street, Bjarke Ingels Group (BIG) produced a tower that wasn't tall or spindly at all: a pyramid of apartments around their own, protected central park. Something new under the New York City sun.

These projects, with their sparkling, pointy, and pop-out facades, are spectacular variations on a 1970s theme. In December 2016, the former Citicorp Center became the city's youngest landmark, at thirty-eight, but its Late Modern style has never been more au courant. You'll recognize that building for its top, lopped off at a forty-five-degree angle, but architects Hugh Stubbins and Associates also gave its square shaft exceedingly smooth steel-clad sides, and tucked a mixed-use atrium and a tiny church at its base. It combines structural drama with a toylike simplicity of form, wrapping the complex package in a practically seamless skin. No one in the 1970s thought to make their curtain wall pop, as Herzog & de Meuron do at 56 Leonard, where the glass can barely contain the Jenga-like ins and outs, but the crenellated roofline at Der Scutt Architect's 1983 Trump Tower sketches a similar idea. Ateliers Jean Nouvel's 100 Eleventh Avenue breaks up a shining facade into spangles, while The Spiral at Hudson Yards and 2 World Trade Center, both by BIG, turn the skyscraper into a city-scaled StairMaster. Maki and Associates' 4 World Trade Center moves a giant structure toward Minimalism, making a corner as sharp as a knife.

All of these buildings are odes to capital, as their 1970s predecessors were, so appreciating them as a luxury good feels tired. Greater interest lies in where they are in the city—on the fringes of established neighborhoods, or establishing the edges of new ones, creating new frontiers for work and play. At ground level, they appear as another glowing lobby, another interior mall, and do little for the street.

Where, then, can we find intimacy, materiality, hush? Muschamp thought we might find it in a museum—he was wrong. Williams and Tsien's American Folk Art Museum appears nowhere in this book, since it now appears nowhere in New York. It was demolished in 2014, at age thirteen, to make way for yet another addition to the Museum of Modern Art (MoMA)—the previous one, designed by Yoshio Taniguchi, was completed in 2004—as well as an adjacent tower, 53W53, by Ateliers Jean Nouvel. Where the folk art museum saw strength in smallness, New York's leading institutions have spent the past decade beefing up. Alongside MoMA there's the Metropolitan Museum of Art, which has an addition by David Chipperfield Architects on hold, and temporarily has Marcel Breuer's former Whitney Museum of American Art building under its wing. The American Museum of Natural History added the cubic, transparent Hayden Planetarium in 2000, and now has a new addition by Studio Gang in progress that looks to the canyons rather than the stars for inspiration.

The Whitney moved downtown, to the southern end of the High Line, where Renzo Piano could indulge his love of marine metaphor in a structure that marries outdoor

sculpture decks with a set of clean, no-fuss, column-free galleries. Flexibility and scale—spaces dark enough for video art, or grand enough to exhibit room-size artifacts—are what directors desire, along with the elusive, legible traffic pattern. Even Allied Works Architecture's renovation of the Museum of Arts and Design, at 2 Columbus Circle, seeks neutrality rather than the original Edward Durell Stone building's controversial pop lollipop columns (of which Muschamp also approved). SANAA's New Museum seems more like an oversize gallery; only Pipilotti Rist's 2016 retrospective, stocked with soft carpeting, beds, and beanbags, made its concrete floors a place to linger long.

The architects hired to make and remake these institutions are the same architects building residential and commercial towers elsewhere in the city, and their architectural language often overlaps. Chipperfield's mixed-use tower at 40 Bryant Park, overlooking the New York Public Library, has a heavy, buttery facade of precast terrazzo panels, a simplified nod to the neoclassical that would not look out of place attached to the Met. Piano's Whitney is a less refined, more complex form than his two projects uptown: the New York Times Building on 8th Avenue, a square tower with a close-fitting cloak of pale terra-cotta bars, and a purposefully low-key addition to the Morgan Library & Museum, punctuating its neoclassical mansions with refined glass boxes. The architects change the shapes, depending on client and neighborhood, but don't change their fundamental language. Piano is icy, Chipperfield creamy, Nouvel glittery.

Nouvel's tower will contain new MoMA galleries, but Diller Scofidio + Renfro are working with the museum on its interior, spread across many earlier iterations of the museum. The one space the museum is leaving largely unchanged is its garden, an oasis of modernist calm, designed by Philip Johnson. Their instinct to preserve this outdoor space (if little else) seems exactly right for right now, as perversely, it is in parks that New Yorkers now find time and space to pull up a chair. It isn't art but landscape that creates a twenty-first-century urban fireside.

Take Nouvel's building for Jane's Carousel. It is located at the edge of Brooklyn Bridge Park, which is designed by Michael Van Valkenburgh Associates. The park stretches from Pier 6, south of the Brooklyn Bridge, to just north of the Manhattan Bridge, its undulating paths forking toward soccer fields, basketball courts, and, between the bridges, the diamantine box Nouvel built around a lushly painted nineteenth-century carousel. The box, whose sides fold open to let in waterfront breezes, frames views of both the river and its bridges, as well as the ride itself, further enhancing its inherent attractions. Nouvel understood that linear parks need punctuation, and that a little bit of his signature flash would not be unwelcome in the otherwise low-key and practical landscape design. You can shelter from a storm inside the box, riding a gold-trimmed horse as raindrops fall against the windows, or simply use it as a backdrop for oh-so-Brooklyn wedding photos.

Tod Williams Billie Tsien Architects' American Folk Art Museum may have disappeared, but several of its characteristic materials, including arboreal Heath tile walls, reappeared in Prospect Park, where their LeFrak Center at Lakeside, a year-round skating rink, provides a strikingly adult cover for the Top 40 sound track that accompanies the activities under its broad, tablelike roof. The underside of the roof, painted cerulean blue and scored with curves and twizzles, mirrors the activity underneath. You can cozy up with a cup of hot chocolate on the green roof and monitor both a tiny skater and the swans a-swimming on the adjacent lake.

The High Line's extreme popularity makes it harder to find peace there, but its design, by James Corner Field Operations and Diller Scofidio + Renfro, also creates hearths for watching people, cars, and the architectural parade that passes along its length. The concrete-and-wood benches that curve up from the linear park paving provide a half step out of the relentless flow of gawkers; get there early for the loungers north of 14th Street. The drop-down bleacher at the 10th Avenue Square is a perfect place to stop for lunch picked up at the nearby Chelsea Market. Children press their noses to the floor-to-ceiling glass at its base, where taxis seem to flow uptown from underneath their feet. At 23rd Street, wooden steps and a scrap of carefully tended lawn focus attention on the array of exhibitionist residential buildings that have sprung up in the High Line's wake. Their exhibitionism is often architectural, as at Neil M. Denari Architects' HL23 or Zaha Hadid Architects' 520 West 28th Street, not to mention Gehry Partners' scudding IAC Building, but it can also be simply a by-product of contemporary condominiums' penchant for floor-to-ceiling glass. Foster + Partners' 551 West 21st Street wouldn't exist without Richard Meier & Partners Architects' 165 Charles Street, which wouldn't exist without his 173 and 176 Perry Street—a pair of petite, largely transparent towers, completed in 2003, that set "glass house in the sky" as the downtown standard. Tiny tots get the best view, however, through a peephole in the playground at 30th Street. Through it they can look north to the whole new section of the city emerging at Hudson Yards, led by KPF's 10 Hudson Yards.

BIG's VIA 57 WEST has been justly celebrated for redefining the shape that a Manhattan rental building might take, by stacking its seven-hundred-plus apartments not in a boring old tower but in a warped pyramid, peaking in one corner at 467 feet (142 m) and then sloping down, for almost a full city block, toward the Hudson River. A long, narrow courtyard is sliced into the center, giving many apartments a view of the landscape near and far, winding paths and an outdoor fire pit in their backyard, the river and the New Jersey Palisades in the distance. Borrowed landscape is a trick itself borrowed from Japanese gardens but, of course, in New York, it gets jumped up a scale.

The other quality Muschamp admired in the Folk Art Museum was its aspiration to create a new kind of small-scale, urban, sculptural space that can only be experienced inside and out. Not a park or pavilion, out there in the open, or part of the skyline sweepstakes, accessible to a few. Selldorf Architects' Sunset Park Material Recovery Facility, on the waterfront in Sunset Park, Brooklyn, provides an unexpected version of this intimacy. Simple like a shed, but exquisitely detailed, the plant is a minimalist museum of utility, reframing trash removal as more than an ugly necessity. On the flat ground in front of the entrance, shallow beds hold instead of plants, which might not stand up to the wind and weather, iridescent baths of recycled glass. When I visited with my children, they filled their pockets with the "gems," suddenly seeing jam jars and soda bottles in a whole new light. Glassiness you can touch.

The recycling plant makes urban infrastructure into something to be celebrated—like the new Second Avenue Subway—rather than hidden out of sight. The best New York architecture of the last fifteen years gives people places to get together and go together, not more reflective walls in which to check yourself out. The city's rebirth, post-9/11, is best judged by accumulations of people on the streets, in parks, and even in some of those behemoth museums, making something intimate out of an ever-larger, ever-taller, ever-more-diverse New York.

WHITNEY MUSEUM OF AMERICAN ART

Renzo Piano Building Workshop
2015
99 Gansevoort Street

In 2015, the Whitney Museum of American Art left its iconic Marcel Breuer–designed Madison Avenue location for a newly designed Renzo Piano sculptural masterpiece in the Meatpacking District. The new destination museum has 50,000 square feet (4,645 sq. m) of indoor galleries and 13,000 square feet (1,207 sq. m) of outdoor exhibition space and terraces. Over one-third of that space is dedicated to special exhibitions in the largest column-free museum gallery space in New York City. Piano's design includes an educational center, multiuse black box theater, one-hundred-seventy-seat theater, works-on-paper study center, conservation lab, library reading room, retail shop, and Untitled, Danny Meyer's restaurant and café.

**Diller Scofidio + Renfro,
James Corner Field Operations,
and Piet Oudolf
2014
Gansevoort Street to
West 34th Street**

Snaking through the backside of Chelsea, the High Line is one of the city's most visited public spaces. Diller Scofidio + Renfro, James Corner Field Operations, and planting designer Piet Oudolf were selected to design the project from an open competition of more than 720 submissions. DS+R refer to this project as a scaling back of architecture. The structure, an abandoned and overgrown railroad, was already there. They tailored the railroad with walkways, wooden lounge chairs, concrete seating, outdoor amphitheaters, and staircases to make the site accessible and enjoyable. Built in three phases, the 1.5-mile (2.4 km) High Line spans from Gansevoort Street to 34th Street, presenting breathtaking views of the Hudson River, Meatpacking District, and Chelsea. High Line Art and other public art organizations utilize it as a venue for artistic and cultural installations, performances, and events.

THE HIGH LINE

Neil M. Denari Architects
2012
517 West 23rd Street

The south side of HL23 is nearly all glass. The east side of the building is nearly all stainless steel. The glass takes advantage of its location along the High Line to give its residents prime views of the abandoned-railway-turned-public-park. Meanwhile, the stainless steel side enables privacy for its residents. Los Angeles–based architect Neil Denari sculpted a cantilevered form that rises above and slightly over a corner of the High Line. This is Denari's first freestanding building. The glass facade offers some of the largest single-pane windows, 11 x 6 feet (3.3 x 1.8 m), ever used on a residential high-rise. Nine full-floor condominiums and two duplexes occupy all but the ground floor, which provides gallery space for the Chelsea arts district.

HL23

KPF
2016
10 Hudson Yards

A confluence of architectural and urban planning energies promise New York City's Hudson Yards as the city's newest desired neighborhood, elegantly incorporating an abundance of residential, retail, corporate, and garden spaces. Fifty-two stories of an all-glass facade ascend into a crowning triangle to announce itself as 10 Hudson Yards, the area's first completed tower (sixteen towers are planned). The building straddles the northern end of the High Line where the public can peer into the building and its massive fifteen-story atrium, free of columnar support. Building occupants can access the High Line directly, or opt to look at it from the tenth-story private terrace.

10 HUDSON YARDS

Bjarke Ingels Group
2016
625 West 57th Street

As the first New York project designed by Danish architecture firm Bjarke Ingels Group (BIG), the architects combined a European sensibility for compact perimeter block buildings with the towering metropolitan skyline. A 22,000-square-foot (2,043 sq. m) courtyard designed with the exact same proportions of Central Park, only thirteen thousand times smaller, faces the Hudson River. On the east side of the residential building, its triangular structure slopes upward 467 feet (142 m) into a near spire. Its prime location along the Hudson River highlights its emphasis on natural resources. Each apartment has a bay window, a balcony, or a floor-to-ceiling window. Besides 709 rental residences, the building offers 45,000 square feet (4,180 sq. m) of retail space and a future Livanos Restaurant Group location.

VIA 57 WEST

THE NEW YORK TIMES BUILDING

Renzo Piano Building Workshop
2007
242 West 41st Street

Unlike past newsroom models, Renzo Piano Building Workshop redesigned the New York Times Building to emphasize light, openness, and transparency, producing a clear visual bridge between the newspaper and the public. The fifty-two-story building is clad in an off-white curtain wall of ceramic tubes that fades into the sky five floors above the rooftop while disguising the tower's mechanical utilities. The ceramic wall also reduces energy and regulates interior lighting and temperature. Interior staircases connect the various newsrooms. The lobby, visible and accessible to the public by its glass windows, features both an open-air courtyard and a vibrant red auditorium.

Renzo Piano Building Workshop
2006
225 Madison Avenue

Renzo Piano's renovation and expansion of the Morgan Library & Museum increased its available space by nearly 75,000 square feet (6,967 sq. m) by digging underground. The construction project kept most of the existing architecture intact to focus on three new buildings and a glass-enclosed central plaza. This expansion, which moved the library's entrance to Madison Avenue, was a result of a growing collection and greater numbers of visitors. The new underground vault houses the library's expanding rare book collections and a two-hundred-sixty-seat auditorium, while three new pavilions offer increased exhibition spaces, reading rooms, and offices. Italian Renaissance chambers inspired the cube format of the smallest gallery, the Clare Eddy Thaw Gallery. Natural light illuminates the exhibition spaces that are clad in rose-hued faceted steel-and-glass curtain walls that complement the existing museum and library exteriors.

THE MORGAN LIBRARY & MUSEUM

Pei Cobb Freed & Partners
2015
1045 Avenue of the Americas

Overlooking Bryant Park and the New York Public Library's Stephen A. Schwarzman Building, 7 Bryant Park provides unparalleled views of greenery in a city short on nature. Henry Cobb of Pei Cobb Freed & Partners unveiled a two-tiered mid-rise office building with an hourglass indentation along the northeast corner. As the indentation makes its way down toward the building's entrance, a steel galactic disk hovers to create a covered plaza and entranceway. At night, different colors illuminate the corner detailing. Besides views of Bryant Park, the New York Public Library, and the surrounding Midtown architecture, the penthouse triplex will offer a unique outdoor terrace for the office. The thirty-story building is devoted to office rentals, with ground-floor retail opportunities.

7 BRYANT PARK

**Rafael Viñoly Architects
2015
432 Park Avenue**

By the time of its completion, 432 Park Avenue skyrocketed above every building in its vicinity to become the tallest residential tower in the Western Hemisphere. Between East 56th and 57th Streets, Rafael Viñoly's design surpasses other iconic New York skyscrapers like the Empire State Building and the Chrysler Building. Its simplistic form is inspired by the purity of a square and its massive height allows the building to offer units from studios to six-bedroom penthouses with a personal library. Yet for all its space, it has a limited amount of 106 units. After every twelve floors, two floors of the geometric grid are left open so that wind can pass through the building and prevent building sway. Deborah Berke designed the interiors and Australian-born, Michelin-starred chef Shaun Hergatt and restaurateur Scott Sozmen preside over a residents-only private restaurant.

432 PARK AVENUE

Christian de Portzamparc
2014
157 West 57th Street

The L-shaped plot determined the form for One57, the Midtown skyscraper offering unobstructed views of Central Park to both residents and hotel guests alike. Pritzker Prize–winning French architect Christian de Portzamparc designed the building during the 2008 economic crisis. The bottom portion of the building is the flagship Hyatt property, Park Hyatt Hotel, while the upper floors are reserved for private residences. It was briefly the tallest residential building in New York City, yet it qualifies as a "supertall" building by surpassing 1,000 feet (304.8 m), the first of its kind to be built in over four decades. It is home to the most expensive residences ever sold in this city. Besides its towering height, the building stands apart from its neighborhood with its patterned facade of metal ribbons weaving behind vertical glass panels. In effect, the exterior becomes a shimmering, patterned surface reflective of the light around it.

ONE 57

**Skidmore, Owings & Merrill
with David M. Childs
2003
10 Columbus Circle**

There is hardly anything a visitor cannot find at the Time Warner Center in Columbus Circle. Two complementary towers join at podium level to house luxury hotel rooms, condominiums, subway access, retail shops, offices, performance venues, and the CNN television studios. It pushes the concept of mixed use to its extreme. Designed by David M. Childs with Mustafa K. Abadan, the facade curves around the traffic circle at the southwest corner of New York's Central Park, and the two towers align with the diagonal direction of Broadway. The transparency of the building's glass exterior and atrium help to integrate the building into its densely populated location.

TIME WARNER CENTER

Foster + Partners with James Carpenter Design Associates
2006
300 West 57th Street

In 1928, media mogul William Randolph Hearst commissioned a six-story building as the base for a future Columbus Circle skyscraper. The base was built, but the Great Depression halted further construction. In 2006, nearly eighty years later, the tower was completed. With the addition of forty-four stories, the original building became a six-floor lobby distinguished by James Carpenter Design Associates' Ice Falls, a three-story water sculpture that regulates the interior temperature. The triangulated diagrid form of the bracing reduces the building's steel use by 20 percent and uses 85 percent recycled steel. Hearst Tower is New York City's first LEED Gold–certified skyscraper. It was also the city's first skyscraper erected after September 11, 2001.

HEARST TOWER

Diller Scofidio + Renfro
2009
10 Lincoln Center Plaza

The Lincoln Center for the Performing Arts renovation began in 2002 as more than just an upgrade, but a massive overhaul and modernization of the Lincoln Center campus designed to redefine its engagement with the city. As a cluster of performing arts venues and institutions, Lincoln Center carries with it a significant cultural responsibility to the people of Manhattan, which the architects emphasized in their open and transparent design. Among the renovations were Alice Tully Hall's lobby, box office, and interior; The Juilliard School; the School of American Ballet's expansion; the Josie Robertson Plaza along Columbus Avenue; a 65th Street pedestrian bridge; and Hypar Pavilion. The Hypar Pavilion, completed in 2010, is one of the more notable features providing a slanted grass roof for pedestrian leisure atop a high-end restaurant. The glass President's Bridge allows visitors to cross 65th Street without going outside.

LINCOLN CENTER FOR THE PERFORMING ARTS

70

**Polshek Partnership
(now Ennead Architects)
2000
200 Central Park West**

In 2000, the American Museum of Natural History's Hayden Planetarium was upgraded to the Rose Center for Earth and Space. Six stories high and 87 feet (26.5 m) wide, the spherical planetarium whose predecessor was demolished in 1997 appears to float above the ground. However, truss work supports the structure and a new glass cube encases it. Once inside the planetarium, visitors encounter the Big Bang Theater where celebrities narrate a four-minute program about the birth of the universe. The Heilbrunn Cosmic Pathway wraps around the sphere, providing a thirteen-billion-year history of the universe. On the top level, visitors can enjoy the Star Theater's high-resolution space shows based on current scientific data. A new parking structure, Columbus Avenue entrance, glass walkway, and educational resource center are all part of the construction as well.

HAYDEN PLANETARIUM

76

Handel Architects
2015
170 Amsterdam Avenue

Utilizing an exoskeleton design of crossing concrete columns, 170 Amsterdam brings to the Upper West Side a striking residential building with an abundance of city views without being another bland glass tower. Those views fall upon Central Park West and Lincoln Center. At twenty stories high, this building provides luxury living worthy of downtown residential envy. The concrete is made to look like limestone and it extends above the building and into the sidewalk below. The external bracing, also referred to as a diagrid, allows increased space and natural lighting within each of the building's apartments.

Adjaye Associates
2015
898 St. Nicholas Avenue

David Adjaye redefines mixed use in the Sugar Hill Development by bringing together affordable housing, a school, and a museum under one roof. The museum, Sugar Hill Children's Museum of Art & Storytelling, offers interactive exhibitions, workshops, performance spaces, and artists-in-residence studios with 124 units that provide affordable housing in the floors above. Broadway Housing Communities, a nonprofit developer whose offices are also in the new building, provided most of the funding for the project. The architect and developers designed the building with the community in mind to hopefully combat the area's notorious lack of housing. Abstract roses adorn the concrete exterior to reference the historical architectural decorations within the neighborhood, while the north and south facades echo nearby row houses. At the ninth floor, the building shifts back to create an outdoor terrace.

SUGAR HILL DEVELOPMENT

84

NORTHWEST CORNER BUILDING

Moneo Brock Studio
2010
550 West 120th Street

José Rafael Moneo's design for the Northwest Corner Building at Columbia University was in large part informed by its structural approach—essentially a building set on top of another, in this case the existing ground-level Francis S. Levien Gymnasium. The seven stories above are braced entirely from the outside, which forgoes interior columns or support. These seven floors are double-height laboratory spaces that provide solid strength for heavy scientific and mechanical equipment. This structural system creates an exterior pattern of geometric diagonal lines that sits above a carved stone base with large windows at its entrance. Cantilevered bridges connect this building to the neighboring Pupin Physics Laboratories and Chandler Laboratories. The new design also incorporates a spacious library and café.

Renzo Piano Building Workshop
2017
605 West 129th Street

The nine-story, transparent Jerome L. Greene Science Center is the first completed building of Columbia University's new Manhattanville campus. Renzo Piano Building Workshop and Skidmore, Owings & Merrill collaborated on the LEED-ND Platinum-certified master plans for this campus' new cluster of buildings. Architect Renzo Piano describes the Jerome L. Greene Science Center, home of the Mortimer B. Zuckerman Mind Brain Behavior Institute, as both a palace and a factory. Its industrial feel corresponds to the building's location merely inches away from the elevated 1 train subway tracks. Yet the glass curtain wall, supported by exterior bracing and steel beams, prevents the classic subway roar from being heard within. Public interactivity is encouraged by the street wall's transparency (required by the district) and access on the ground level featuring a Wellness Center, Education Lab, shops, restaurants, and more.

JEROME L. GREENE SCIENCE CENTER

Diller Scofidio + Renfro with Gensler
2016
104 Haven Avenue

With Diller Scofidio + Renfro as design architect and Gensler as executive architect, the redesigned Roy and Diana Vagelos Education Center at Columbia University presents a new vision of the modern-day medical school. The 100,000-square-foot (9,290 sq. m), fourteen-story glass tower offers a heightened relationship between space and academic performance. The "Study Cascade," fourteen stories of varying indoor, outdoor, individual, collaborative, and social spaces, defines the building. A single staircase connects the numerous elements. "Academic neighborhoods" allow constant reconfiguration of drop-down screens, partitions, and suspended ceilings. Performance plays into this new conception of a medical school, as there is a 275-seat auditorium intended more for campus-wide activities, as well as multiple rooms for simulating medical procedures.

ROY AND DIANA VAGELOS EDUCATION CENTER

**Steven Holl Architects
2013
Broadway and 218th Street**

Columbia University's Campbell Sports Center is an athletics facility built on stilts. The structure maneuvers above sloped streets and elevated subway tracks to become a cubist cluster of concrete, steel, and sanded aluminum boxes and external staircases. The new cornerstone of Columbia's outdoor sports program adds almost 48,000 square feet (4,459 sq. m) of space for athletics and student athletes. Large glass windows allow student athletes to look out over the remaining Baker Athletics Complex facilities and the surrounding Inwood neighborhood. The facility is designed by architect Steven Holl, himself a professor at the university's Graduate School of Architecture, Planning, and Preservation.

CAMPBELL SPORTS CENTER

**Grimshaw Architects and
Dattner Architects
2012
700 Brook Avenue, Bronx**

The name, Via Verde, suggests the prominence of green living and green space in this mixed-use complex jointly designed by Grimshaw Architects and Dattner Architects. The winner of the international New Housing New York Legacy Competition that offers 222 apartments for this Bronx community, as well as retail spaces, Via Verde is a three-part building with a twenty-story tower, a mid-rise duplex, and town houses. A ground-level courtyard spirals upward along south-facing roof gardens to culminate in a top-floor terrace. Rather than offering the prime top-floor real estate to one resident, a large community room is instead open to all tenants. A 5,500-square-foot (510 sq. m) wellness center, operated by Montefiore Medical Center, further incorporates health and wellness into the residents' lives.

VIA VERDE

Louis I. Kahn
2012
Roosevelt Island

Floating in New York's East River is a small island dedicated to former president Franklin D. Roosevelt. At the island's southern tip, late architect Louis I. Kahn designed his last work to honor the president's January 6, 1941, State of the Union address that celebrates the four freedoms: freedom of speech, freedom of worship, freedom from want, and freedom from fear. The designs for the park were in Kahn's briefcase when he passed away in 1974, which makes this park also a tribute to the architect himself.

Kahn conceived the park in 1973 as a room and a garden, and it was executed with the help of New York–based firm Mitchell / Giurgola Architects. The garden is a triangular glassy plain flanked on both sides by Littleleaf Linden trees. At its helm, a large sculpted bust of the president himself introduces the outdoor room with cement blocks inscribed with excerpts from Roosevelt's speech. The park, which offers field trip options for students, invites visitors to reflect on the late president's legacy and the surrounding city.

FRANKLIN D. ROOSEVELT FOUR FREEDOMS PARK

**Ateliers Jean Nouvel
2011
Brooklyn Bridge Park**

Commissioned to encase a restored 1922 carousel between the Manhattan and Brooklyn Bridges, the $9 million structure by Pritzker Prize–winning architect Jean Nouvel shines like a jewel box on the shore of the East River. It is both decadent and minimalist as it sits on the waterfront of Brooklyn's industrial Dumbo neighborhood. The French architect fought for its 72-foot-square (6.68 sq. m) shape, rather than the original circular request. He also opted for acrylic, not glass, to create a subtle distortion of reflections. During both day and night, the architecture works with the inner carousel to create a shimmering spectacle. Two of the four acrylic walls retract during the day to open up the space. At night, the structure becomes a magic lantern as the horses project shadows onto the pavilion's white screens.

JANE'S CAROUSEL

SHoP Architects
2012
620 Atlantic Avenue, Brooklyn

Barclays Center is the first construction in a massive redevelopment of Atlantic Yards. The mixed-use neighborhood within a neighborhood will ultimately include seventeen high-rise buildings across 22 acres (8.9 ha). Boldly situated at the triangular intersection of Atlantic and Flatbush Avenues, 12,000 unique, pre-weathered steel panels decorate a swooping thirty-foot-high canopy with an inner oculus framing the view of the SHoP-designed arena. That inner oculus provides 3,000 square feet (278.8 sq. m) of digital signage. Home to the Brooklyn Nets and the New York Islanders, Barclays Center also functions as a major entertainment and performance arena seating up to nineteen thousand people. Besides the arena, it offers a hundred luxury suites, multiple bars and lounges, three clubs, the 40/40 Club by American Express, and a green roof for sound insulation.

BARCLAYS CENTER

Tod Williams Billie Tsien Architects
2013
Prospect Park, Brooklyn

Nestled near the southeast corner of Brooklyn's Prospect Park, the LeFrak Center at Lakeside offers something for every season. Tod Williams Billie Tsien Architects incorporated a minimal amount of architecture—two single-story structures connected by a plant-covered roof-level bridge—into the busy Frederick Law Olmsted–designed park. In the winter, the rinks are set up for ice-skating, while in the summer there's roller skating and a bustling water park. The roof above the rink is decorated by an abstract pattern that mimics the patterns of the skaters. The two buildings house additional recreational facilities and spaces, including a café, event spaces, and offices. It has been awarded Gold LEED certification. The surrounding park landscape, a total of 26 acres (10.5 ha), has also been restored with the collaboration of Christian Zimmerman, chief landscape architect of the Prospect Park Alliance.

LEFRAK CENTER AT LAKESIDE

SUNSET PARK MATERIAL RECOVERY FACILITY

Selldorf Architects
2013
472 2nd Avenue, Brooklyn

Annabelle Selldorf's elegant, state-of-the-art Sunset Park Material Recovery Facility in Brooklyn hopes to change New York City's relationship with recycling. For one, it will cut costs by reducing the amount of recycling exported outside of the state. Receiving deliveries by barge, as opposed to trucks, decreases environmental impact. And recycled materials from other construction projects, such as the Second Avenue Subway, were used as the buildings' materials. Three buildings, the Tipping Building (where the recyclables arrive); the Processing and Bale Storage Building; and the Administrative and Education Center make up the 140,000-square-foot (13,006 sq. m) site. A pedestrian bridge connects two of those buildings to allow visitors to watch the curbside metal, glass, and plastic be processed. And, to avoid its fate as another box warehouse, the entire structure of lateral bracing and steel girders is exposed along the exterior of the building.

Gehry Partners
2011
8 Spruce Street

A subtle sculptural wave moves across the facade of Frank Gehry's 8 Spruce Street skyscraper, creating an iconic Gehry stamp upon his first residential commission in the city. New York by Gehry, formally known as Beekman Tower, is a seventy-six-story, rental-only building with a public elementary school housed in its lower five floors. Offering around nine hundred units, the building boasts amenities typical of any New York high-rise: indoor swimming pool, barbecue areas, outdoor terraces, Pilates studio, and fitness center. But it is the exterior that draws the most attention. Each of the 10,500 stainless steel panels that make up the surface of the building are individually designed, similar to Gehry's Guggenheim Bilbao, not so subtly distinguishing the tower from so many of its neighboring Wall Street buildings.

NEW YORK BY GEHRY

Grimshaw Architects with
Arup and James Carpenter
Design Associates
2014
200 Broadway

The Sky Reflector-Net, James Carpenter's conical glass roof of tensioned cables, high-strength rods, stainless steel, and perforated aluminum panels, soars above the 300,000 commuters passing daily through the Fulton Street Station. Connected underground to the nearby Oculus building designed by Santiago Calatrava, Fulton Center continues the ongoing revitalization of lower Manhattan. Eight MTA subway lines converge at the busy station along with a diversity of enticing commercial and culinary options. Businesses from Shake Shack to Moleskin line the multilevel, circular central space. This is the first MTA subway station to receive LEED certification.

FULTON CENTER

Herzog & de Meuron
2016
56 Leonard Street

With a specially commissioned artwork by Turner Prize–winning artist Anish Kapoor emerging out of the base of the building, 56 Leonard playfully challenges design from its top to its bottom. Each floor of the sixty-story building offers private outdoor space opening on to spectacular views. Herzog & de Meuron designed stacks of glass boxes that call to mind the game Jenga. Within those glass boxes are 145 homes, and nine floors of penthouses with custom-designed grand piano–shaped kitchen islands. The Tribeca building boasts a library lounge, indoor and outdoor theaters, sky estuary with seventy-five-foot infinity-edge lap pool, outdoor sundeck, private dining salon, and more.

56 LEONARD

Dattner Architects with WXY
2015
336 Spring Street

Form meets function at the Department of Sanitation's Spring Street Salt Shed in which the building used to house salt is actually designed to resemble salt. Nearly 70 feet tall (21.3 m) and 6,300 square feet (585 sq. m), this reinforced concrete enclosure can hold 5,000 tons of salt to clear the city's streets in winter weather. Every design element of this structure is purposeful. Its situation along the Hudson River enables quick access to the salt deliveries arriving from Chile or Argentina. Its riverside walls are taller than the rest to conform to the way the pile of salt will naturally slant. The concrete is tinted blue so that as the building ages it will wear to the color of salt. And yet for as much as this concrete mass stands apart from its lower Manhattan surroundings, it complements the building across the street, the Manhattan Districts 1/2/5 Garage, also designed by Dattner Architects and WXY.

SPRING STREET SALT SHED

Richard Meier & Partners Architects
2006
165 Charles Street

165 Charles Street is the third Richard Meier design within a two-block radius in New York's Greenwich Village. In 2002, he completed 173 and 176 Perry Street, and in 2006 he added to the pair with 165 Charles Street. A central spine divides this sixteen-story building to create a set of two-bedroom apartments on nearly all levels. The first two levels are one-bedroom, double-height apartments and the top floor is reserved for a duplex penthouse. Located along the Hudson River like the two Perry Street buildings, 165 Charles Street boasts an all-glass facade. Meier's designs extend into the interiors of the apartments as well. Unlike the other two buildings, this location won the American Institute of Architects 2005 Housing Design Award.

165 CHARLES STREET

**Gehry Partners
2007
550 West 18th Street**

World-renowned architect Frank Gehry made his New York debut in 2007 with the whimsical, all-glass facade InterActiveCorp (IAC) headquarters in Chelsea. The project was a collaborative vision with Barry Diller, chairman and senior executive of IAC, who wanted to stay away from typical corporate office buildings. Because of Diller, Gehry refrained from wrinkled titanium and instead selected smooth, curving glass. This is Gehry's first all-glass exterior. The form of the building conveys a nautical feel with its sharp folds and flowing white. Of the 1,437 exterior glass panels, 1,349 are completely unique in their shape and twist. The glass was cold-warped on-site to fit the sinuous form of the building. A wraparound terrace on the sixth floor provides outdoor spaces for employees. Two touch-screen video walls within the lobby promote content from IAC's inventory of media companies. At night, the white melts away and the interior lights of the building turn it into a deep orange.

IAC BUILDING

Ateliers Jean Nouvel
2010
100 11th Avenue

Each of the nearly 1,650 colorless windowpanes along the curved exterior of Jean Nouvel's 100 Eleventh Avenue residential tower tilts at a slightly unique angle, making it the most complex curtain wall engineered in New York City. Rooted along the edge of Chelsea's gallery district, the building takes full advantage of its riverside views with its glass exterior. However, the opposite side of the building drastically differs from the glittering glass facing the Hudson River—a solid wall with only a handful of punched windows. The building is entirely residential with seventy-two apartments. At its base is "the Loggia," the semi-enclosed atrium decorated with fully grown trees and plantings floating from steel structures.

100 ELEVENTH AVENUE

Foster + Partners
2012
551 West 21st Street

Foster + Partners frames the windows of this luxury apartment tower in an opulent gold trim that mimics the framed artworks of the neighboring Chelsea art galleries. The building glistens when the sun hits the golden detailing, reflecting the sun's light as residents gaze out onto downtown Manhattan and the Hudson River. An external grid of white precast concrete establishes the structure of the building, while the glass windows fill the spaces between. Manicured hedges crown the building's base and an internal ivy-clad driveway offers a private entrance for the residents. Two glass-fluted elevators direct residents into their private elevator landings, and eventually to the penthouse with its own private outdoor lap pool.

551 WEST 21ST STREET

CetraRuddy
2013
23 East 22nd Street

CetraRuddy's design for One Madison prove that the size of a building's footprint does not diminish its dreams for height. The residential tower located along Madison Square Park, just one block from the city's iconic Flatiron Building, is notable for its extreme slenderness at 620 feet (188.9 m) with a 12:1 proportion. One Madison is a sixty-story tower of cantilevered glass cubes perched along the main shaft of the building. That main shaft is constructed in earth-toned bronze glass to assimilate and pay respect to the historical masonry of the surrounding architecture. The cantilevered design creates occasional apartment terraces. CetraRuddy takes advantage of the central location within Manhattan to offer a surplus of cinematic, 360-degree views that stretch from the Hudson River to the East River. Quite a feat for a building that was once almost a casualty of New York's volatile real estate market.

ONE MADISON

Skidmore, Owings & Merrill
2014
63 5th Avenue

The New School expanded its footprint within the city by adding its University Center, all 375,000 square feet (37,838 sq. m) of it, to the corner of 14th Street and 5th Avenue. Roger Duffy of Skidmore, Owings & Merrill designed the building for living, academic, and performance spaces. Its grand staircase, marked by glass panels along the outside of the building, is the signature feature of this building in that it connects the bottom seven floors to enable communication, collaboration, and interaction among students. The center houses fifty-seven state-of-the-art classrooms, studios, instructional spaces, nine floors of student dormitories, a two-level library, and an eight-hundred-seat auditorium. None of the classrooms are designed for specific disciplines in order to facilitate and foster maximum interdisciplinarity.

THE NEW SCHOOL UNIVERSITY CENTER

**Morphosis
2009
41 Cooper Square**

West Coast architect Thom Mayne's designs for 41 Cooper Square sought to create a space to merge art, architecture, and engineering at Cooper Union for the Advancement of Science and Art. Nine stories tall and 175,000 square feet (16,258 sq. m), this building takes up an entire block on the border of the East Village. An aggressive perforated stainless steel curtain wall wraps the building with only a few slits for windows and a slight lift for the ground-level entrance. Glass windows bridge the building's ground floor to the street. Mayne crafted a central atrium to feel like a public square where interactions are constantly possible. A 20-foot-wide (6 m) staircase ascending from the lobby to the fourth floor is the main vertebra of this vision of interaction, reinforced by main elevators that only stop at the first, fifth, and eighth floors. 41 Cooper Square is the first LEED-certified academic laboratory building in New York City.

41 COOPER SQUARE

Maki and Associates
2013
51 Astor Place

51 Astor Place rivals other New York City office buildings in its massive width, rather than height. At 400,000 square feet (37,161 sq. m) and 12 stories, it avoids blending into its East Village surroundings. However, between this building and the nearby Cooper Union building designed by Morphosis, an architectural shift may be taking place. Sharp angles and edges conjoin in a stepped-down volume clad entirely in dark glass that reflects the sky and its surroundings. IBM is one of the main tenants, as well as a handful of other technology companies. Further marking its distinction from the storied neighborhood, an imposing Jeff Koons red balloon bunny sculpture decorates the building's lobby.

51 ASTOR PLACE

Selldorf Architects
2015
10 Bond Street

The newest residential development to arise along the historic two-block Bond Street in Manhattan's NoHo, Annabelle Selldorf's 10 Bond Street is boldly situated on the corner of Bond and Lafayette. The seven-story, hand-cast terra-cotta building features expansive floor-to-ceiling windows for light to filter in and residents to peer out. The terra-cotta was an intentional choice, inspired by the rusted cast iron architecture and brick of the landmarked district. Selldorf's firm is typically known for designing galleries and museums around the world, but 10 Bond Street presents a more intimate experience in the limited amount of its residential offerings. It houses one penthouse with a wraparound terrace, one town house, and nine apartments, two or three bedrooms each. The ground level is reserved for retail spaces such as a yoga shop, and the lower-level fitness center overlooks a sunken landscape garden. Selldorf designed both the architecture and the interior of the building to create a cohesive environment inside and out.

10 BOND STREET

Herzog & de Meuron
2007
40 Bond Street

Bringing both town houses and condominium apartments together, Herzog & de Meuron bridges two distinct sensibilities into a modern building at 40 Bond Street. The five street-level town houses are shielded from the public sidewalk by a sculptural 140-foot-long (42.60 m) cast-iron wall. The intricate design of the wall utilized computer technology to re-create New York City graffiti tags into three-dimensional form, referencing the neighborhood's roots. This heavy ornamentation contrasts from the smooth, straight, clean lines of the remainder of the building above—twenty-three condominiums and one penthouse. Altogether, the building stands eleven floors high. Emerald-colored glass, supposedly the color of glass itself, outlines the floor-to-ceiling windows of the apartments, producing a grid effect in stark contrast with the two levels of town houses below. Each town house has a front porch, back garden, and communal garden between the third and fourth units.

SANAA
2007
235 Bowery

Tokyo-based architects Kazuyo Sejima and Ryue Nishizawa of SANAA, recipients of the Pritzker Prize in 2010, were faced with many spatial restrictions when initiating designs for the Bowery's new and contemporary art museum. In response, they designed a seven-story, eight-level structure of gray rectangular boxes each shifted slightly away from the central core of the building. In effect, it produces gallery spaces of varying sizes with alternating degrees of natural light, while providing high ceilings and no interior columns. An aluminum mesh clads the exterior of these boxes while the entire base facade is clad in glass, establishing an inviting openness between the art and the street.

NEW MUSEUM

Foster + Partners
2010
257 Bowery

Sperone Westwater Gallery's new Bowery location allows visitors to view art while traveling between the floors via the Moving Room, a 12 x 20-foot (3.6 x 6 m) exhibition space that moves up and down the five-story building like an elevator. The exterior of the building is a combination of corrugated black metal panels and laminated glass. The effect creates a slightly transparent structure rising nine stories above the red brick of its neighborhood. Besides extending the gallery space, the Moving Room insulates the building from extreme temperatures and provides acoustic insulation. The gallery's relocation from Chelsea to the Lower East Side enabled an aesthetic reconsideration of what a gallery space is and can be. In correspondence with the project's innovation, Foster + Partners received awards from organizations such as the Municipal Art Society of New York and the Royal Institute of British Architects.

SPERONE WESTWATER GALLERY

**Bernard Tschumi Architects
2007
105 Norfolk Street**

Not only is the BLUE Residential Tower the first residential building and skyscraper designed by architect Bernard Tschumi, but it was also the first building on the Lower East Side to offer such amenities as twenty-four-hour doorman service and cold storage for food deliveries. The architect maneuvered his way through zoning restrictions to eventually design a cantilevered, angled form with seventeen floors of slanting walls. From every angle the building takes on a different form and towers above most buildings in the neighborhood. Its exterior is a constellation of blue-and-black glass panels reminiscent of the characteristic diversity of the Lower East Side community, while also presenting a witty pixilation of the sky over Manhattan. Among its many strategic uses of space, the building incorporates a neighboring commercial rooftop to create an urban garden for its residences.

BLUE RESIDENTIAL TOWER

**Skidmore, Owings & Merrill
with David M. Childs
2014
285 Fulton Street**

In One World Trade Center (Freedom Tower), Skidmore, Owings & Merrill confronted one of the most complex architectural challenges in recent history. The reconstruction of One World Trade Center needed to serve as a memorial to the buildings that were destroyed, stand as a symbol of the strength of the American people, and provide secure, innovative office space for hundreds of companies. Eight alternating isosceles triangular forms connect the square roof and base of the building. These forms produce constantly shifting refractions of light along the exterior of the building and an octagonal floor plan for the few floors midway to the top. Just below the 408-foot (124 m) spire is a glass observation deck. At 104 stories and 1,776 feet, One World Trade Center is the tallest building in the Western Hemisphere. And its 1,776-foot (541 m) height is a subtle reference to the nation's year of independence, 1776.

ONE WORLD TRADE CENTER

7 WORLD TRADE CENTER

Skidmore, Owings & Merrill with David M. Childs and James Carpenter Design Associates
2006
250 Greenwich Street

The first of the destroyed 9/11 buildings to be rebuilt, 7 World Trade Center's 2006 construction marked more than just another New York skyscraper. Skidmore, Owings & Merrill (SOM) were interested in the street-level interaction of the building and establishing a sense of lightness. The lightness was achieved through the building's glass exterior and a curtain wall that reflects the changing light and colors of the sky. James Carpenter Design Associates collaborated with SOM to create a perforated steel screen that opaquely covers a panel of blue-and-white LED lights. Just below the translucent color-changing envelope is a lobby installation by American text-based artist Jenny Holzer—a continuous stream of celebratory text about New York City visible from both inside and outside the building. This is also the first commercial office building within New York City to receive LEED Gold certification.

Maki and Associates
2013
150 Greenwich Street

The nine-story low-rise building originally located at 4 World Trade Center has been completely replaced by a 978-foot-tall (298 m) glass masterpiece. Pritzker Prize–winning architect Fumihiko Maki designed this all-glass building for the new World Trade Center complex. 4 WTC combines a square structure rising fifty-six floors topped off with a trapezoidal structure for sixteen floors. Two of the building corners are indented inward, increasing the number of corner offices. Like the other accompanying towers, 4 WTC has a glass facade that changes and adjusts to the external temperature and lighting. The majority of the building is given to office spaces, while the bottom levels are reserved for retail and dining.

4 WORLD TRADE CENTER

NATIONAL SEPTEMBER 11 MEMORIAL

Michael Arad and PWP
Landscape Architecture
2011
180 Greenwich Street

Reflecting Absence is the title of Michael Arad's design that won him the commission for the National September 11 Memorial. His design, implemented with its fair share of backlash and controversy, sought to evoke absence and contemplation at the site of a national tragedy. The Israeli American architect worked with landscape architect Peter Walker to design two square pools at the exact placement of the former Twin Towers with a surrounding forest of 416 oak trees. Each void measures one acre (.4 ha) and represents the largest man-made waterfalls in the country. The water slides down granite walls into a seventy-foot central void. The names of the 2,983 victims of the September 11 attacks and the 1993 World Trade Center bombing are inscribed in bronze plates along the ledges according to a formula that positions names with those they were working with at the time of the attacks. The close gathering of trees creates a canopy of outdoor shade while also being a green roof for the museum and transportation facilities underground.

MARY ALICE WAHLSTROM	CAROLYN MAYER BEUG
ANDREW PETER CHARLES CURRY GREEN	CHRIST
MICHAEL THEODORIDIS	RAHMA SALIE AND HER U
JOHN NICHOLAS HUMBER, JR.	DAVID E. R
WALEED JOSEPH ISKANDAR	JEFFREY PETE

NATIONAL SEPTEMBER 11 MEMORIAL MUSEUM'S PAVILION

Snøhetta
2014
180 Greenwich Street

The commemorative complex of the World Trade Center brings together in one place notable designs by some of the world's top architects. Norwegian firm Snøhetta designed the Pavilion—the primary entrance to the Davis Brody Bond–designed belowground museum and the only building on the actual site of the destroyed World Trade Center towers. This pavilion is intended as the spiritual and physical bridge between the outdoor memorials and underground museum. It is an irregularly sloped dual-toned structure made of transparent, reflective, and striped materials. The glass allows visitors to look out and passersby to look in. Two structural beams from the original World Trade Center towers are on display in the museum's atrium.

WORLD TRADE CENTER TRANSPORTATION HUB [THE OCULUS]

Santiago Calatrava
2016
185 Greenwich Street

In the midst of the World Trade Center complex, the Oculus looks like a bird about to soar into the sky. Light fills the indoor space and draws attention upward. Spanish architect Santiago Calatrava was tasked with designing this new site for the World Trade Center Transportation Hub to replace the original one destroyed in the September 11 attacks. The first phase of the Oculus opened on the 15th anniversary of the tragedy. From a ground floor of white Italian marble two curtains of white ribbed steel arch toward one another and then outward, merging overhead at a three-hundred-thirty-foot-long glass skylight. That skylight can open and close, as it will on each anniversary of September 11, 2001. The Oculus serves eleven subway lines and the PATH train, and provides 78,000 square feet (7,246 sq. m) of space for retail and dining.

© Prestel Verlag, Munich · London · New York 2017
A member of Verlagsgruppe Random House GmbH
Neumarkter Strasse 28 · 81673 Munich

In respect to links in the book, Verlagsgruppe Random House expressly
notes that no illegal content was discernible on the linked sites at the
time the links were created. The Publisher has no influence at all over the
current and future design, content or authorship of the linked sites.
For this reason Verlagsgruppe Random House expressly disassociates
itself from all content on linked sites that has been altered since the
link was created and assumes no liability for such content.

Introductory text © 2017 Alexandra Lange
Photography © 2017 Pavel Bendov

Prestel Publishing Ltd.
14-17 Wells Street
London W1T 3PD

Prestel Publishing
900 Broadway, Suite 603
New York, NY 10003

Library of Congress Cataloging-in-Publication Data

Title: New architecture New York.
Description: New York : Prestel Publishing, 2017.
Identifiers: LCCN 2017011963 | ISBN 9783791383682 (hardcover)
Subjects: LCSH: Architecture--New York (State)--New York--History--
21st century. | New York (N.Y.)--Buildings, structures, etc.
Classification: LCC NA735.N5 N395 2017 | DDC 720.9747--dc23
LC record available at https://lccn.loc.gov/2017011963

A CIP catalogue record for this book is available from the British Library.

Editorial direction: Holly La Due
Design and layout: AHL&CO / Peter J. Ahlberg, Anthony Carhuayo
Production management: Luke Chase
Project texts: Sophie Golub
Copyediting: John Son
Proofreading: Kelli Rae Patton

FSC — MIX Paper from responsible sources FSC® C008047

Verlagsgruppe Random House FSC® N001967
Printed on the FSC®-certified paper
Chinese Chenming Snow Eagle FSC matt art

Printed in China

ISBN 978-3-7913-8368-2

www.prestel.com